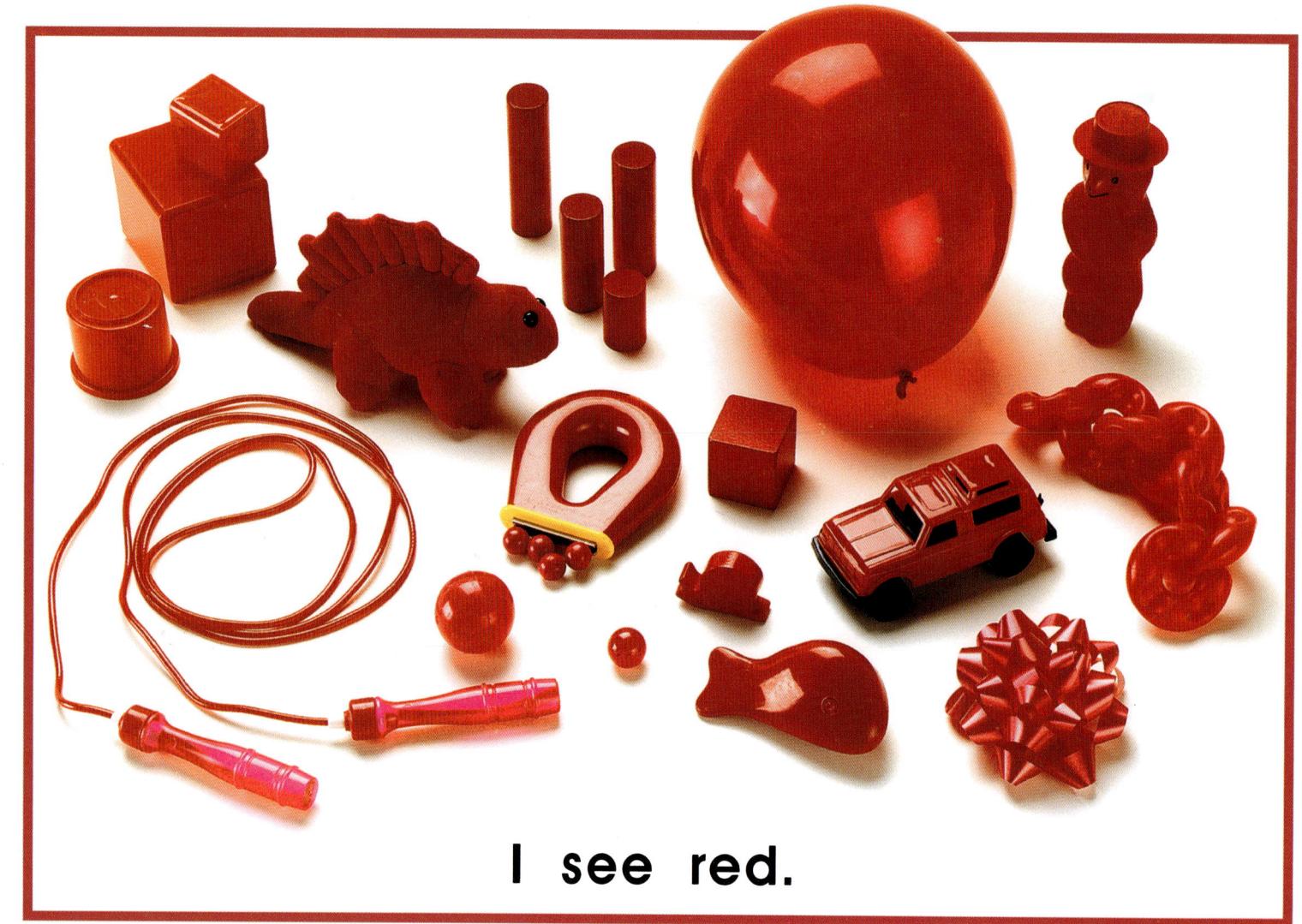

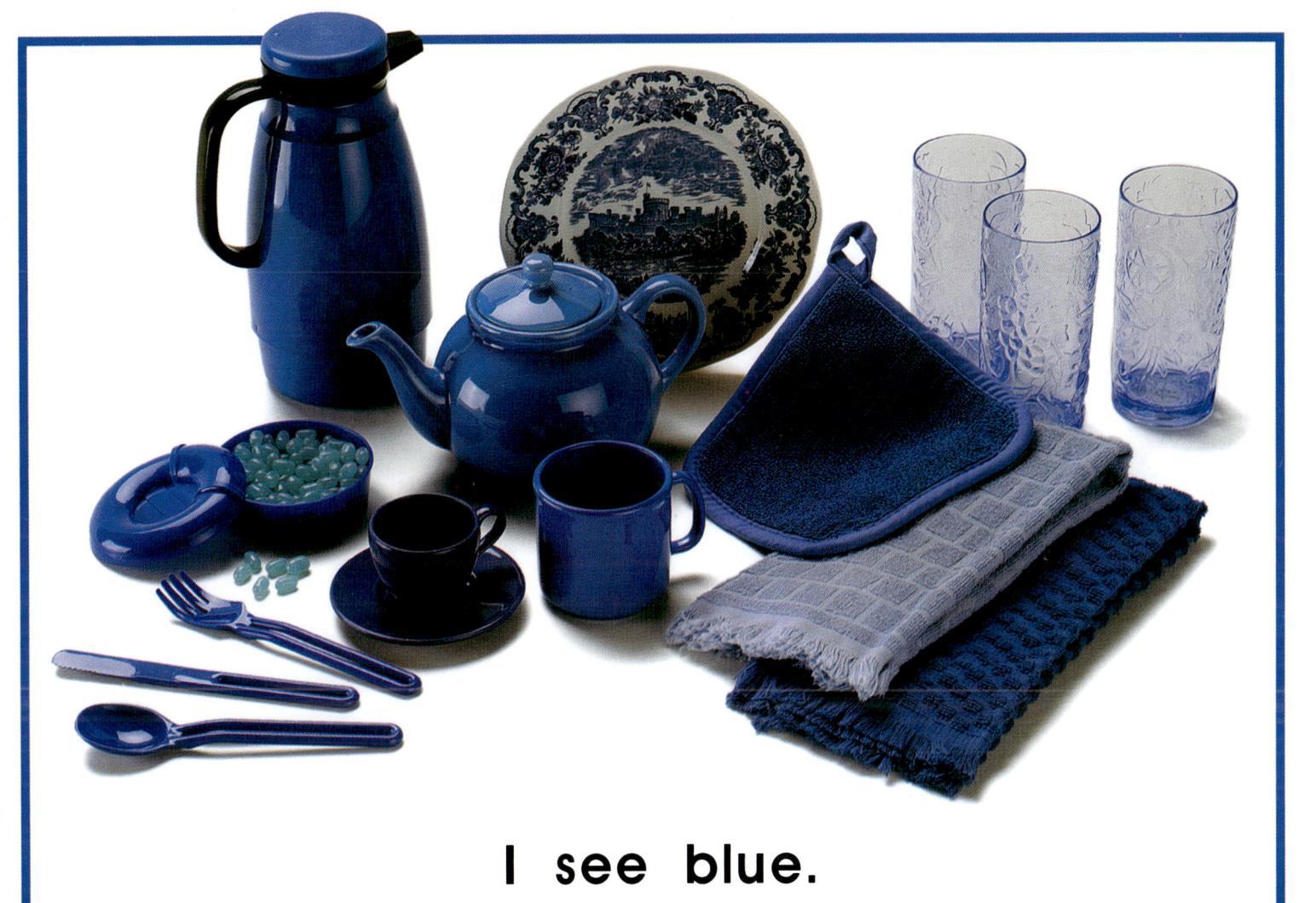

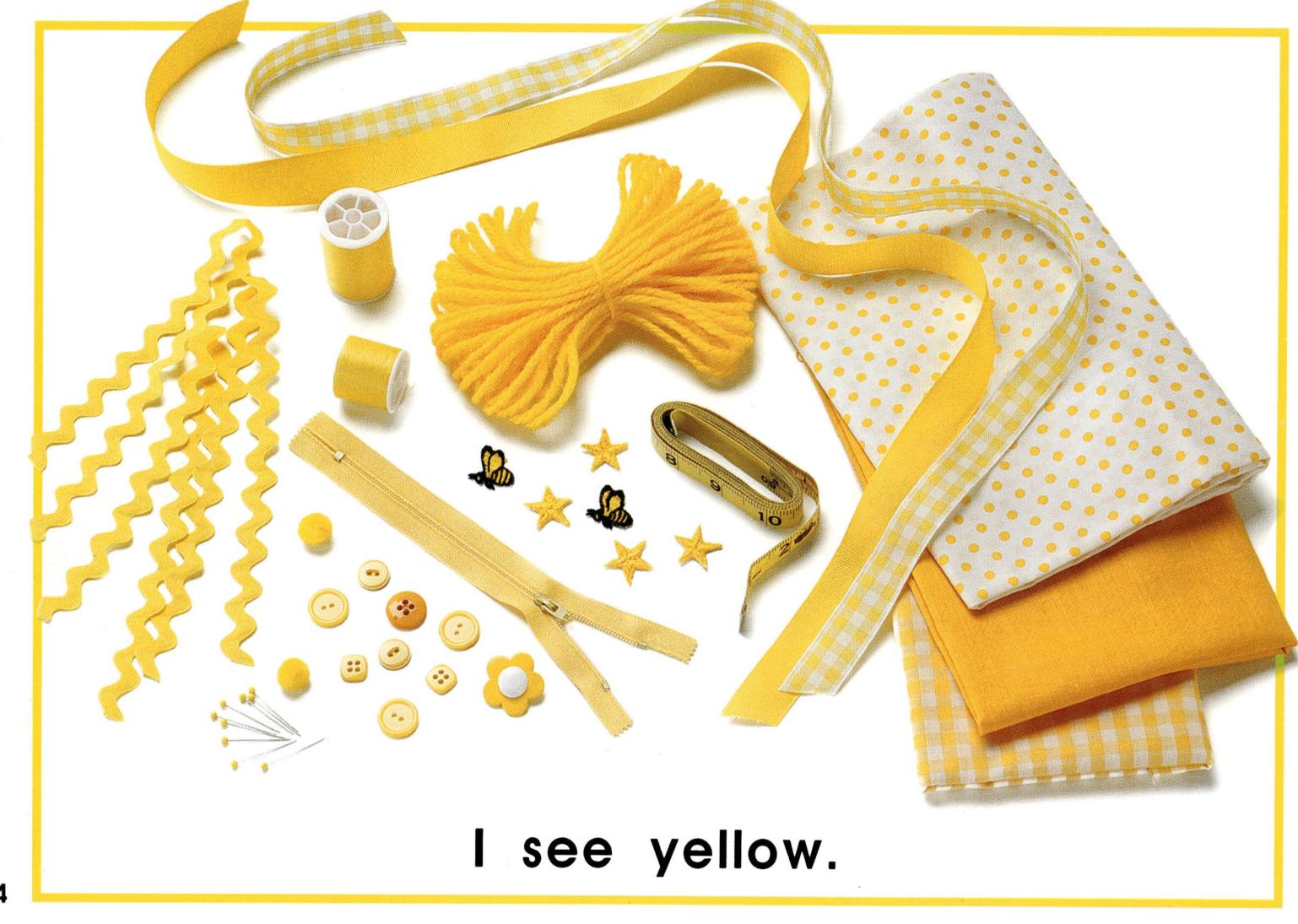

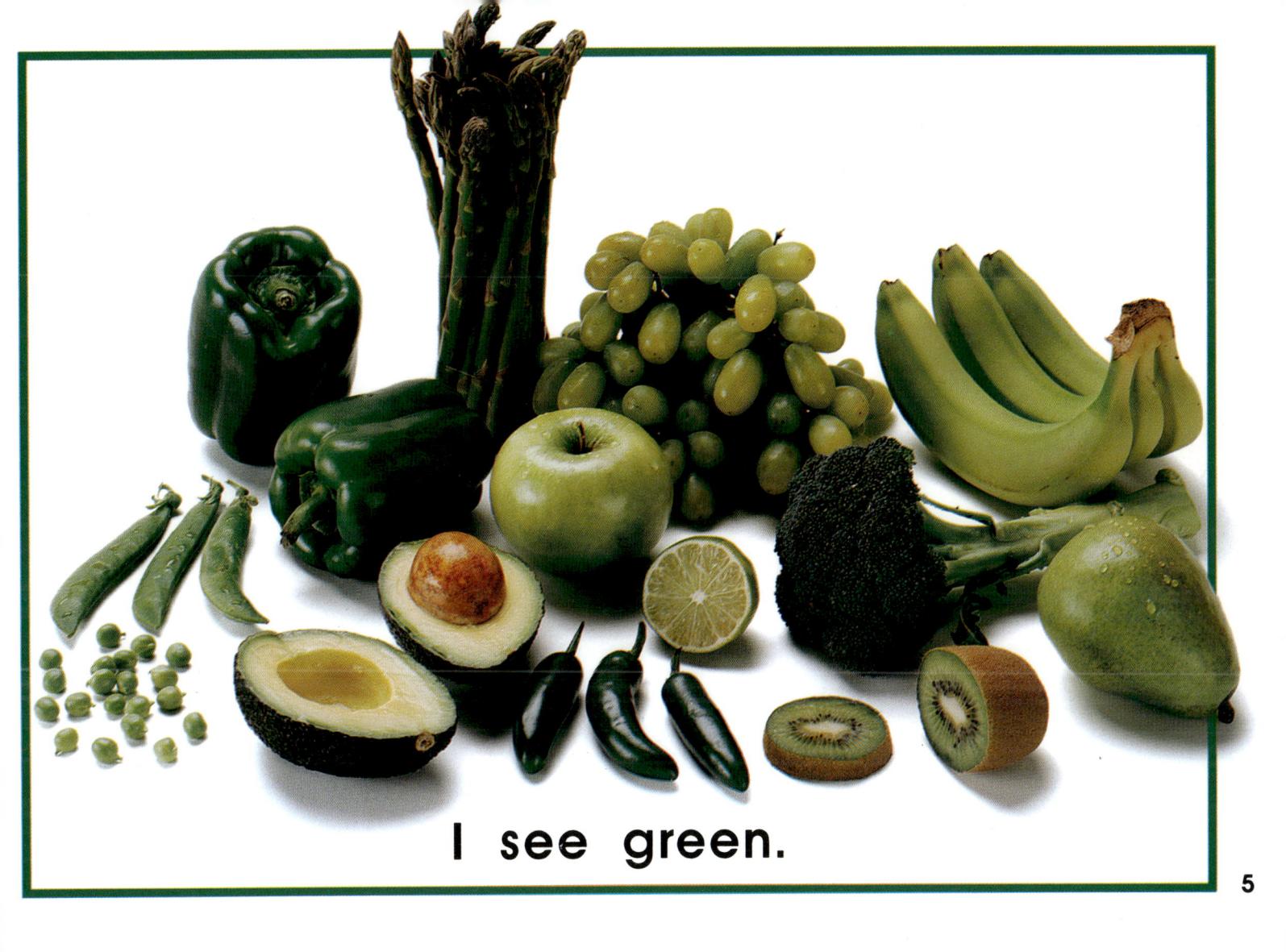

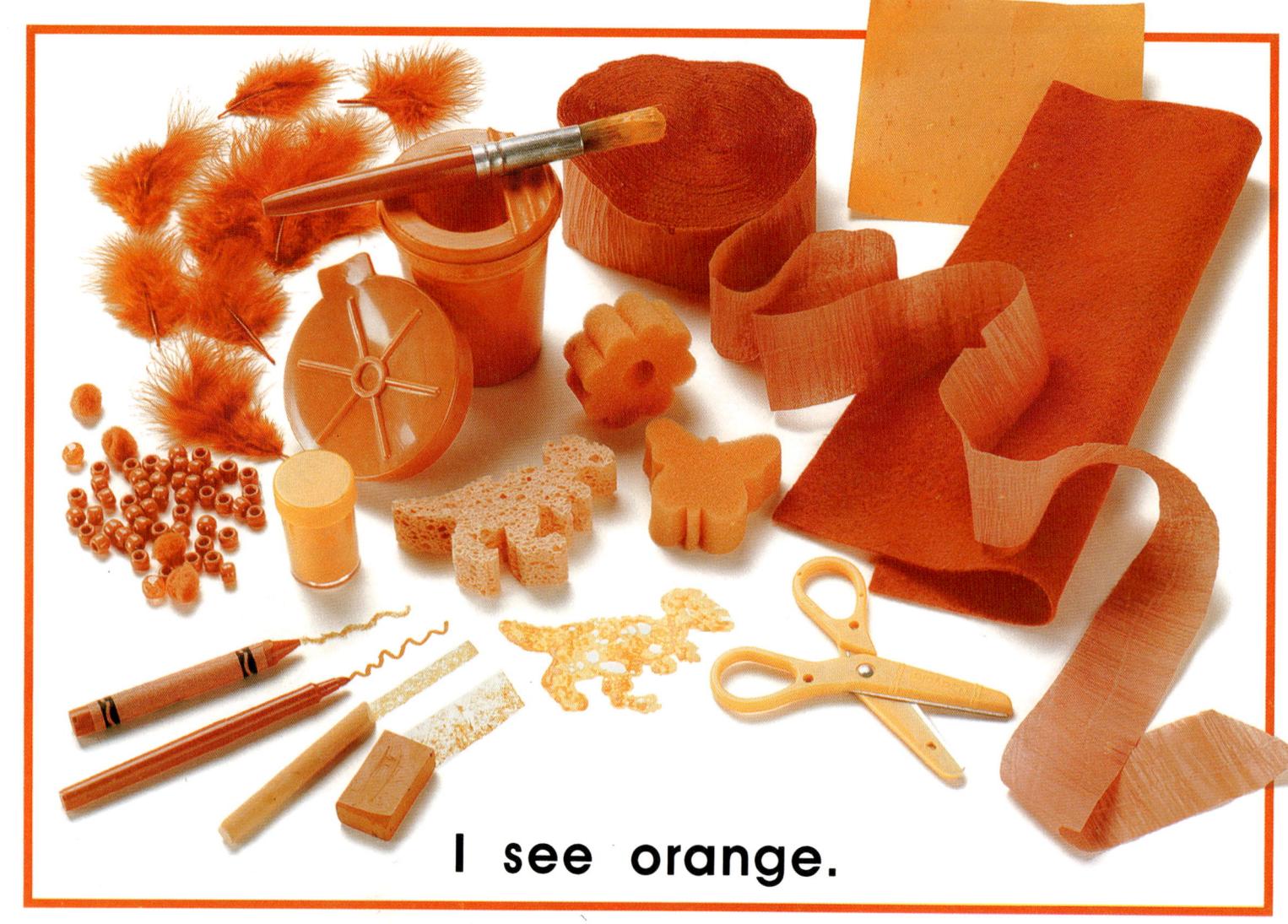

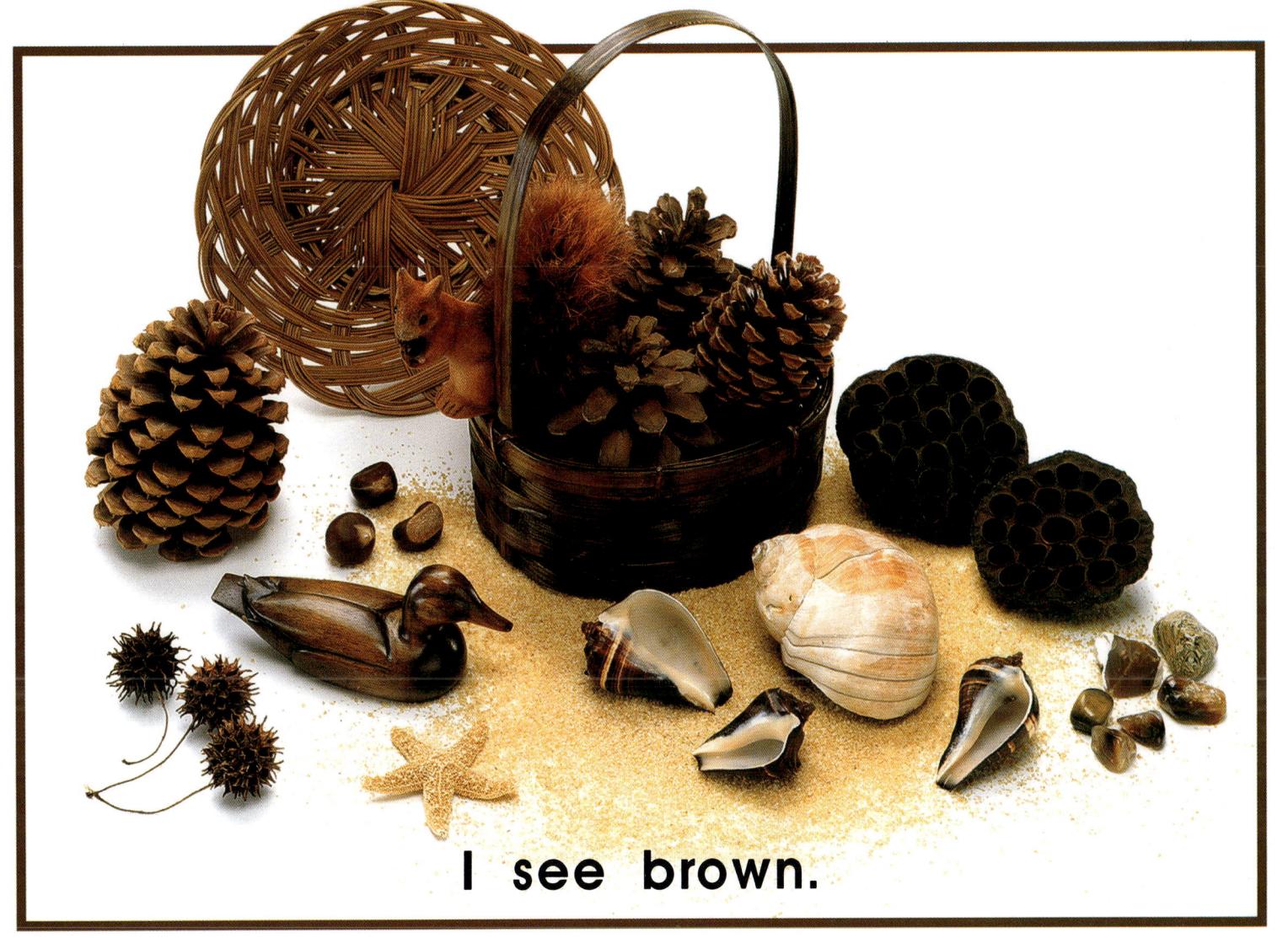

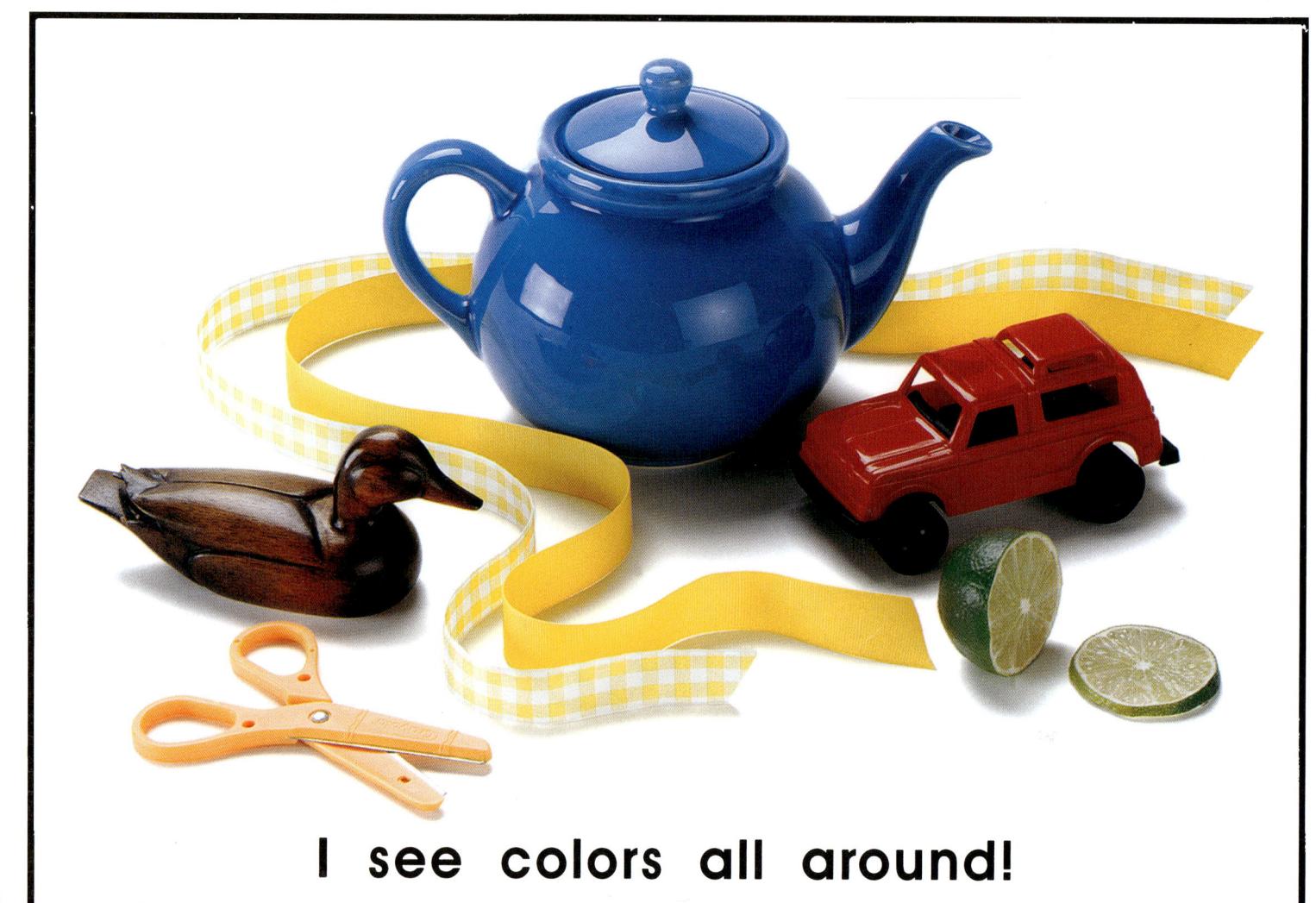